ODILON REDON

EDITED BY

CAROLYN KEAY

Introduction by Thomas Walters

RIZZOLI

ACKNOWLEDGEMENTS

We would like to thank all the museums, galleries, institutions and private collectors who have generously allowed their works to be reproduced. In particular we are grateful to the British Museum for providing photographs of prints in their collection.

Published in the United States of America in 1977 by

RIZZOLI INTERNATIONAL PUBLICATIONS, INC.
712 Fifth Avenue/ New York 10019

© 1977 by Academy Editions, London

Library of Congress Catalog Card Number: 76-62547
ISBN Cloth 0-8478-0070-9 Paperback 0-8478-0088-1

Printed in Great Britain by
William Clowes & Sons Ltd., Beccles, Suffolk

INTRODUCTION

Odilon Redon was born in Bordeaux on April 20 1840. He was the son of a Creole mother, Marie-Odile and a father of French peasant stock, Bertrand Redon who, having sought his fortune in Louisiana, returned to settle in his native Bordeaux. Because of parental neglect Odilon spent most of his childhood in the care of an uncle at Peyrelebade in the Medoc in southwest France. His sensitive and timid manner as a child already showed signs of the developing artist. 'As a child I sought out the shadows. I remember taking a deep and unusual joy in hiding under the big curtains and dark corners of the house.' An attempt to persuade Odilon to pursue a career in architecture having failed, his father eventually allowed him to go to Paris in 1858 to attend the Ecole des Beaux-Arts. Redon failed the entrance examination, and instead began working in the atelier of the academic painter Léon Gérôme. Finding this experience disappointing, and protesting that 'I was tortured by the Professor', he left, bringing to a close his formal academic training.

More important than these first attempts to gain a footing in the Paris art world of the 1850's was his meeting with Rodolphe Bresdin in Bordeaux in 1863. Bresdin, an already accomplished lithographer, taught Redon the methods of print-making and introduced him to the works of Dürer and Rembrandt. Bresdin himself proved to be an important influence upon the impressionable young artist, affecting equally his choice of medium and subject-matter. Early sources for Redon's images can be seen in the strange hybrid creatures of Bresdin's lithographs – mostly the products of an opium-fired imagination. 'The real artist', Bresdin advised his pupil, 'ought not even to look at nature.' Redon always gratefully acknowledged his debt to Bresdin, portraying his teacher in the lithograph entitled *Le liseur* (The Reader), 1892.

Redon later befriended Armand Clavaud, a botanist interested in plant physiology, especially the intermediate biological states between plant and animal life.

Clavaud's research gave Redon his first insight into the discoveries of science, an interest which was to remain with him throughout his artistic career. Redon's fascination with the bacilli and microscopic creatures seen through Clavaud's microscope is clearly evident from the ambiguous forms he drew, even though he was later to note in his journal that they did not 'owe their conception to that terrifying world of the infinitely minute as revealed by the microscope' (*A soi-même*). The collector Gustave Fayet has left a revealing account of Redon's way of working. On visiting the artist's studio in his absence he found a child's zoology book opened to show an illustration of a boa-constrictor next to an easel which bore, half-finished, a painting which embodied an ophidian form in its composition.

Bresdin's influence, and the subsequent acquaintance with Henry Fantin-Latour, directed Redon towards the choice of lithography as a medium. Although Redon had first experimented with paint in the 1860's, he preferred techniques using black and white tones. 'Black is the most essential of all colours . . . It does not waken the eye and awakens no sensuality. It is an agent of the spirit far more than the fine colour of the palette or prism.' Lithography ideally suited his *noirs*, as he referred to them, the evocative qualities of chiaroscuro allowing the exact degree of illusiveness that he sought. Redon's skilful use of black often has the effect of placing the viewer of his works in the type of real-life situation in which darkness or shadow precludes any certainty as to whether he is in the presence of a third party. 'I insist on the fact that my entire art is limited solely to the resources of chiaroscuro, and it also owes a great deal to the effect of abstract line, that power drawn from deep sources which acts directly upon the mind.'

Redon's first series of lithographs was produced in 1879, an album of ten plates entitled *Dans le Rêve* (In the Dream), a collection of apparently strange fantasy images which provoked little public notice. Other than the attention accorded to these works by a few cognoscenti of the art world, the original nature

of the plates went largely unheeded. Each was thoroughly symbolist in subject-matter and the manner of its execution. *Germination*, for example, number two in the series, is composed of what appears to be a dis-embodied head in profile emerging from a black nimbus. One is given the impression that, with its fellow beings, it will fall to a distant earth below, a fate shared by Plato's winged soul journeying through the universe. Its effectiveness, with the other plates in the series, results from its power to suggest meaning without being specific. This and many other works by Redon invite comparison with the drawings of the writer Victor Hugo, which in their subject-matter and style would seem to constitute the most direct and important precedent for Redon's work.

The devices of symbolic art were already familiar conventions used by Old Masters such as Botticelli, and subsequently by the Romantic painters, including Goya and Fuseli. In their hands no distinct separation existed between the symbol and the allegory of which it was a part. Redon's originality lay in his recognition that the symbol could exist in its own right, diffusing mystery and transforming the entire context in which it was placed. What he offers the viewer is a world beyond that of everyday reality, a self-sufficient world with its own, often incongruous, logic.

Redon's reputation as an artist, like his character and his palette, tended to stay in the shadows, largely eclipsed by the dazzling success of the Impressionists. In Redon's eyes Impressionism followed nature too closely in attempting to reproduce faithfully the appearance of the external world, thereby confining itself to the domain of imitation. The critic Emile Hennequin, in reviewing the exhibition of Redon's works organised by the journal *La Vie Moderne* in 1881, observed that Redon had 'managed to conquer a lonely region somewhere on the frontier between the real and imaginery, populating it with frightful ghosts, monsters, monads, composite creatures made of every imaginable human perversity and animal baseness, and all sorts of terrifying inert and baneful things.... His work is bizarre; it attains the grandiose, the delicate, the subtle, the perverse, the seraphic.' The writer Joris Karl Huysmans further commented that 'It is a nightmare carried over into art.' As if in answer Redon, in declaring his own philosophy, demanded 'a right that has been lost and which we must reconquer: the right to fantasy'.

By the time Redon exhibited at the first Salon des Indépendants in 1884 he had produced further series of lithographs, including *A Edgar Poë* (To Edgar Allan Poe), 1882, an album of six plates, *Les Origines* (The Origins), 1883, an album of eight plates, as well as several etchings. His rapidly growing output was earning him the admiration of a number of progressive younger artists, including Maurice Denis of the Nabis and members of the Pont-Aven group under the leadership of Paul Gauguin, all of whom shared with Redon the rejection of the official art taught by the Academies. Their interests revealed a similar concern with the esoteric, the twilight regions of thought and intuition, and in the symbolist method by means of which they communicated their personal visions. Many of these artists also cultivated an interest in the mystical and occult which they saw as the key to experiences different to those revealed by sensory perception.

The inclusion of a description of Redon's works in Huysman's best selling novel *A Rebours*, 1884, did as much to make Redon's name familiar to the public as did his exhibitions. Adorning the walls of the house at Fontenay were '. . . faces, staring out with great, wild, insane eyes, some of these shapes exaggerated out of all measure or distorted as if seen through refracted water, that evoked in Des Esseintes' memory recollections of typhoid fever, remembrances that had stuck persistently in his head of hot nights of misery and horrid childish nightmares'. It was Huysmans who introduced Redon to Stéphane Mallarmé, the leading poet of the Symbolist movement.

Mallarmé stood at the centre of a literary group which also included Paul Verlaine, Gustave Kahn,

Edouard Dujardin and Albert Aurier. Mallarmé's originality stemmed from his interest in the mystery of language, its power to allude and to suggest associations by means of literary devices. Ambiguity, hermeticism, the widespread use of the symbol as catalyst, and the synthetic combination of real and artificial elements were all devices which he employed to produce a sense of a separate but convincing reality in his poetry. It was at Mallarmé's *Mardis*, the Tuesday receptions given for leading figures of the Parisian art world, that Redon encountered sympathetic admirers of his work. Redon came to prefer the company of writers and poets to that of other artists, and many of his works reveal as their source of inspiration literary themes from the works of Edgar Allan Poe, (*A Edgar Poë*), Gustave Flaubert, (*La Tentation de Saint-Antoine*), and Charles Baudelaire, (*Les Fleurs du Mal*). Redon was not, however, a book illustrator, and it would be a mistake to seek in these series visual counterparts to the literary works, since they stem rather from an imaginative sympathy with the author's interests.

The term 'Symbolism' was first coined by Jean Moreas with reference to works of literature in his manifesto published in *Le Figaro* in 1886, in the course of his personal crusade against the naturalism epitomized by the work of Emile Zola. The literary Symbolists took their inspiration from Romanticism, especially from the work of Charles Baudelaire. They developed an aesthetic which served as the ideological background for painters, in whose works they saw the possibilities of giving pictorial expression to the mystical and occult. According to the precepts of Symbolism all arts aspired to be one, and so it was permissible for the Symbolist painters to borrow ideas from the writers. They rejected the notion of the external world as the only creative stimulus and proper 'domain of painting' as formulated by the realist painter Corbet, and instead viewed the natural object as the 'signified idea'. The neo-Platonic basis of their thinking derived from Baudelaire's view of the

visible world as a storehouse of images to which the imagination assigned a place and value. This idealist belief in the function and importance of the imagination implied a correspondence between external forms and subjective states, so that a similar feeling – whether one of intense emotion, a dream or mystical experience – would be suggested through the equivalence of the symbol to the original state of mind. In describing his works Redon stated that 'they are the reverberations of a human expression, that by means of the license to fantasy, have been embodied in a play of arabesques. I believe that this action will originate in the mind of the beholder and will arouse in his imagination any number of fantasies whose meaning will be broad or limited according to his sensitivity and imaginative aptitude to enlarge or diminish' (*A soi-même*).

Redon took subjective experience as his starting point and objectified it within the limits of his medium. 'After attempting to copy minutely a pebble, a sprout of a plant, a hand, a human profile or any other example of living or inorganic life, I experience the onset of a mental excitement: at that point I need to create, to give myself over to representations of the imaginary. Thus blended and infused, nature becomes my source, my yeast and my leaven. I believe that this is the origin of my true inventions' (*A soi-même*). An obvious comparison suggests itself with Coleridge's account of the genesis of his poem *Kubla Khan*, its fantastic images begotten during a laudanum-induced reverie after reading Purchas's *Pilgrimage*. Redon, however, distinguished himself by his abstention from the opium-eaters, among them De Quincy, Piranesi, Poe and Baudelaire.

Redon still regarded nature as his model. The fact that *Oannes*, *Monstre fantastique* (Fantastic Monster) and *Quand s'éveillait la vie au fond de la matière obscure* (When life was awakening in the depths of the dark matter) and other such fantastic creations resemble natural phenomena points to the Surrealist device of incongruous juxtaposition of recognisable objects. Metamorphism and anthropo-

morphism are also evident in his work, traditionally the estate of caricaturists.

Equally equivocal are the titles to his works, many of which are lengthy statements. Redon made the following observation on the subject, 'A title is justified only when it is vague, indeterminate and when it aims even confusedly at the equivocal. My drawings *inspire* and do not offer explanations. They resolve nothing. They place us, just as music does, in the ambiguous world of the indeterminate.' The most important function of the title seems to be that it directs the viewer to a 'way of looking' at the work. The title of plate number two of *La Maison hantée* (The Haunted House), *Je vis une lueur large et pâle* (I saw a large pale light), directs attention to the light area at the left centre of the work, which might otherwise almost be overlooked as a fault of the lithographical process. In consequence this 'large pale light' appears, if inconclusively, spectral.

Redon eventually gave up his *noirs* in 1897 in order to concentrate on painting, an event which coincided with the sale of the family home at Peyrelebade. Consequently the works which were to establish him as a painter of note were not produced until relatively late in his career, around the turn of the century. His transition from the exclusive use of black and white to a free use of colour was a steady if sporadic one, beginning with the early experiments with landscapes in oils painted in the vicinity of Peyrelebade in the 1860s. It was not until the 1880s that colour was to reappear in his work, this time in the form of pastel drawings, the choice of which probably facilitated the change to colour. Redon seems to have enjoyed the luminosity of colour, especially the glowing reds and blues chosen for their expressive qualities. Both the pastel drawing *Verrières* (Stained Glass Windows), 1901, and the oil painting *L'arbre rouge* (Red tree not reddened by the sun), 1905, are examples of an evocative use of pigment to suggest a sense of mystery earlier achieved by the use of chiaroscuro. He generally avoided the thick impasto style of painting characteristic of the Impressionists in favour of a comparatively thin application of paint which often allowed the canvas to show through. What his style lacks in draughtsmanlike precision it gains by a greater freedom of approach. It is, perhaps, to be regretted that he did not devote more time to painting, since wherever he laid brush to canvas he managed to open up an equally fascinating world of colour, the daylight equivalent to the nocturnal world of his lithographs.

By the end of the 1890s Redon's works were being exhibited in France, Belgium, Holland, Germany, Russia and England. He was included in the first Venice Biennale in 1895, and in 1904 the first annual show at the Salon d'Automne gave over an entire room to the exhibition of his works. No less than forty of his pictures were shown in the Armory Show of 1911, which also received enthusiastic public response in the United States. Having struggled for most of his life, Redon was now an internationally successful artist no longer dogged by financial problems. In 1903 he was awarded the Légion d'Honneur, and in 1909 retired to Bièvres near Paris where he died nine years later.

Odilon Redon has the distinction of being one of the earliest and most innovative of the Symbolists, as well as being a precursor of subjectivist tendencies in art of this century. His achievement lay in his extraordinary ability to give life to surreal creations, his power to convey fantasies and anguished dreams in pictorial equivalents possessing a logic of their own. It was the direction and emphasis of Redon's art in which his contribution to the modern movement lay, his work predating the attempts of Chagall and the Surrealists to reveal the unconscious, and the efforts of the Expressionists during the pre-war years to render directly feelings and emotions. The many strange and uncanny images which he produced bear witness to a penetrating vision which was at once eloquent and equivocal, both original and eclectic.

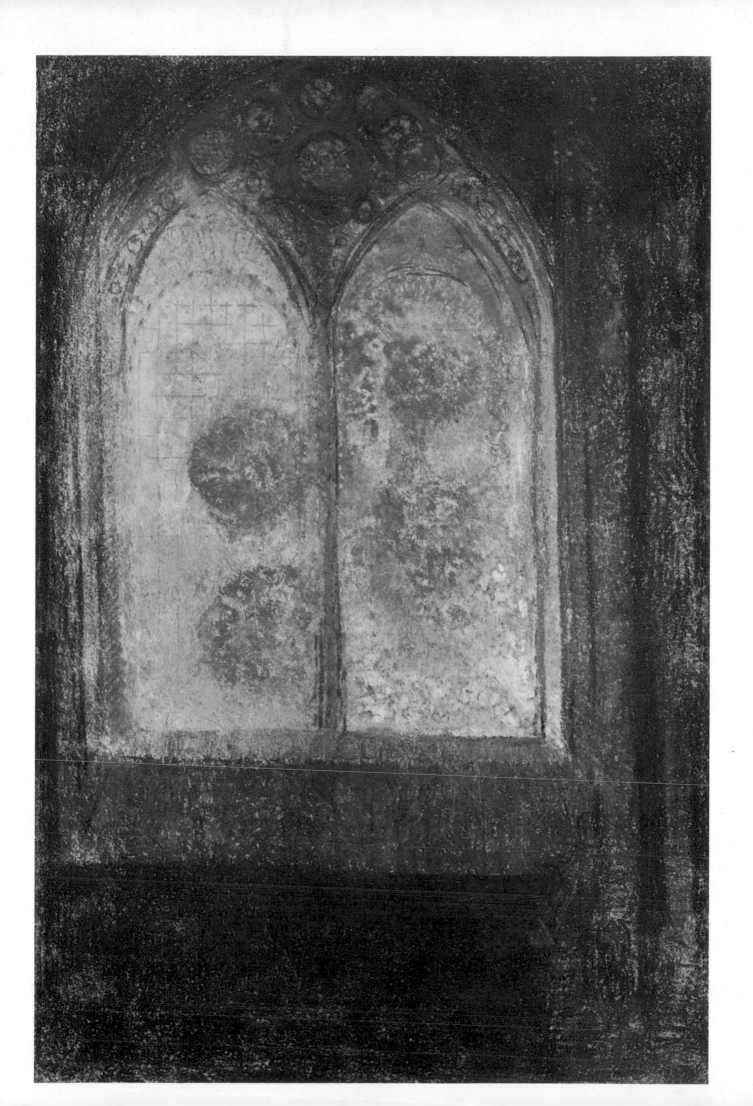

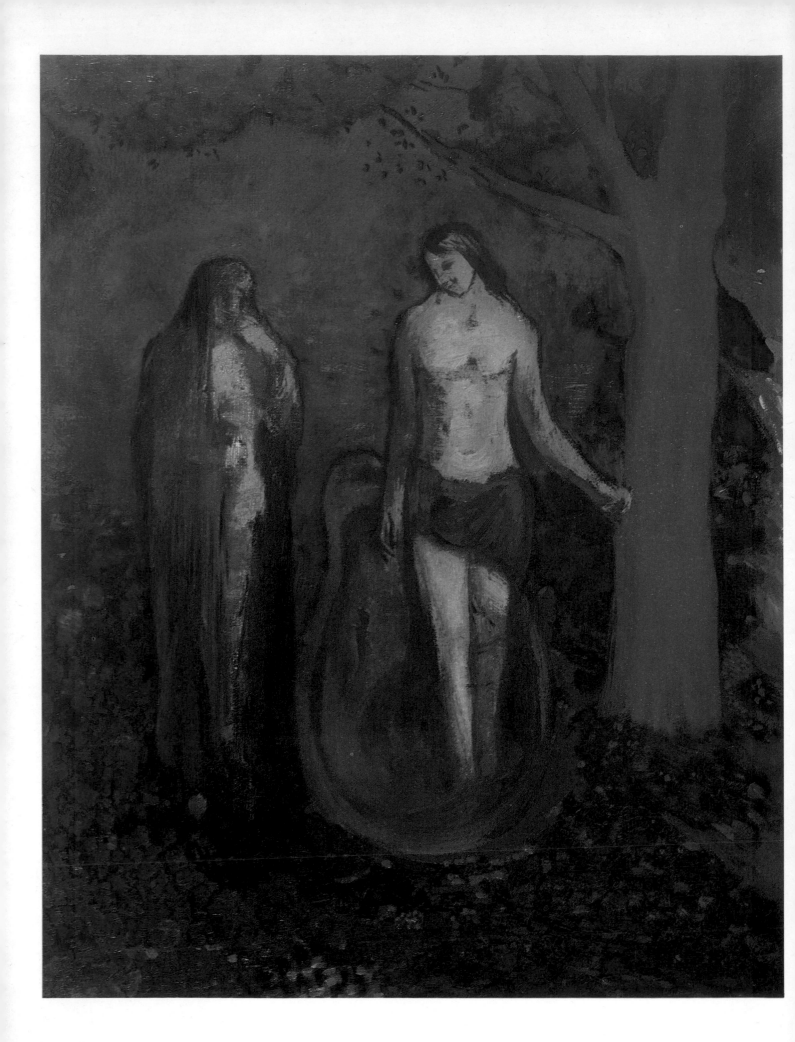

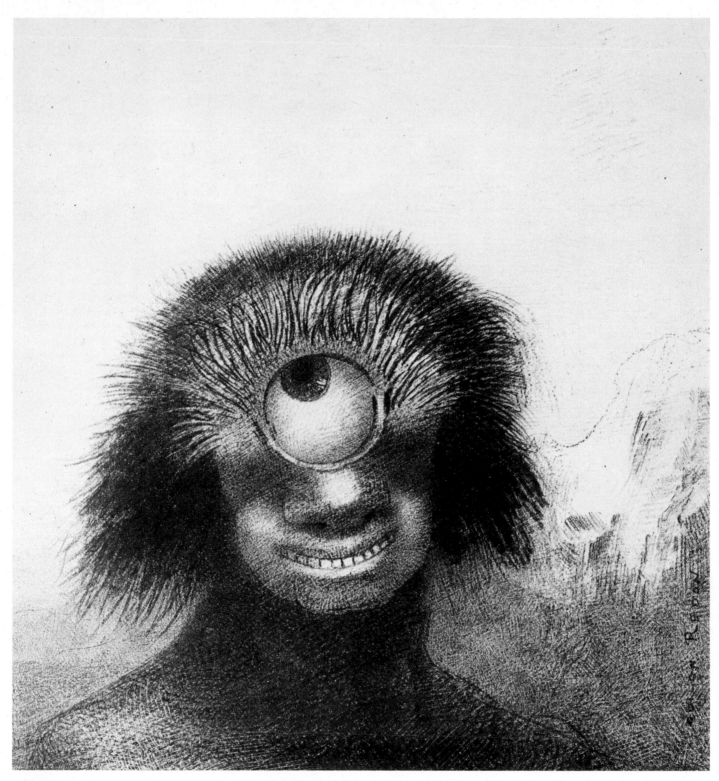

The misshapen polyp floated on the shores, a sort of
smiling and hideous Cyclops / *Le polype difforme flottait
sur les rivages, sorte de Cyclope souriant et hideux*, No. 3
of *Les Origines* 1883
Lithograph 21.3 × 20 cm

Opposite

Red tree not reddened by the sun / *L'arbre rouge* 1905
Oil on canvas 45.7 × 35.5 cm
(Courtesy of Arthur Tooth & Sons Ltd)

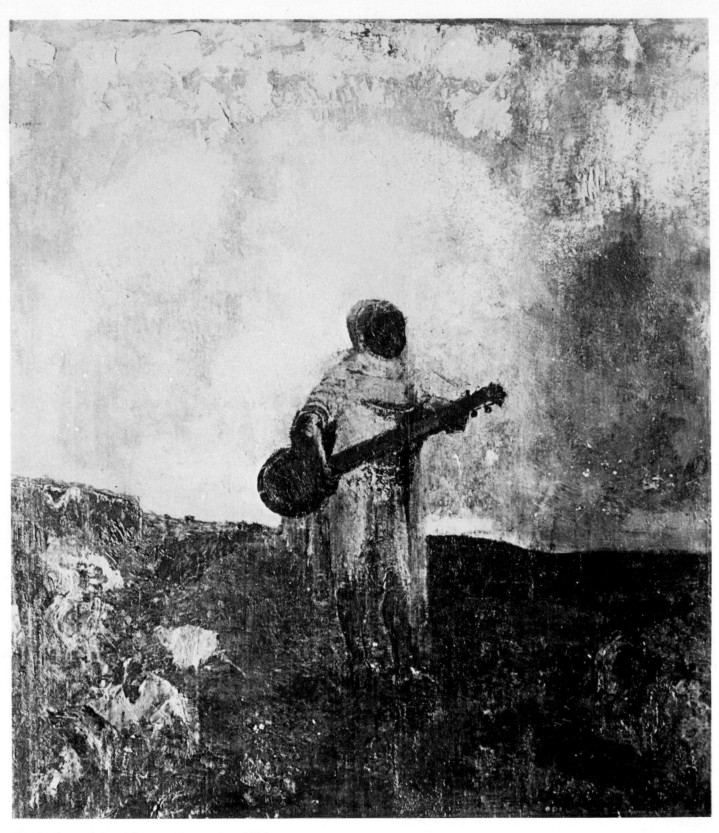

The Arab musician / *Le musicien arabe* 1893
Oil 51 × 44 cm
(Musée du Petit-Palais, Paris)

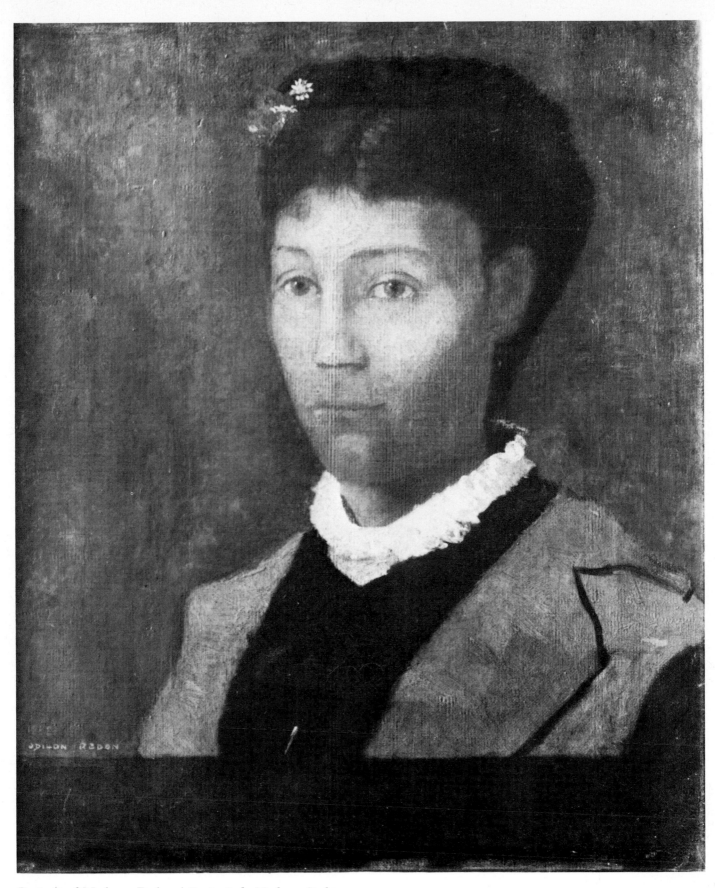

Portrait of Madame Redon / *Portrait de Madame Redon*
1882
Oil 45 × 37 cm
(Musées Nationaux, Paris)

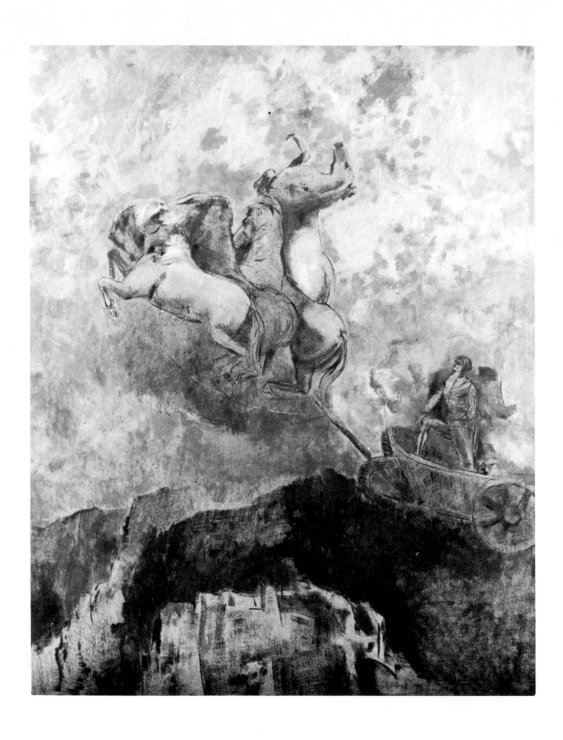

The chariot of Apollo / *Le char d'Apollon* 1909
Oil on board 100 × 80 cm
(Musée des Beaux-Arts, Bordeaux; photo A. Danvers)

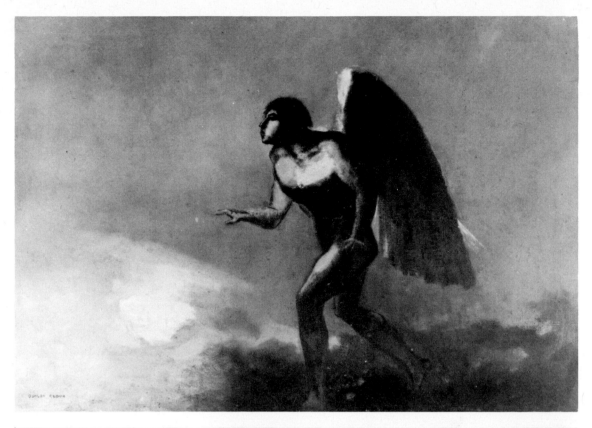

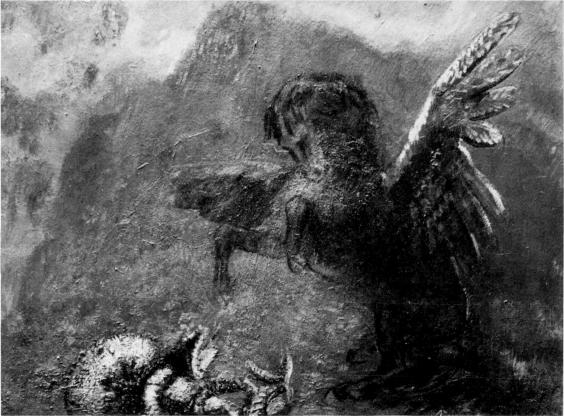

The winged man, or the fallen angel / *L'homme ailé,
on l'ange déchu* c 1890–95
Oil on canvas 24 × 34 cm
(Musée des Beaux-Arts, Bordeaux; photo A. Danvers)

Pegasus and the dragon / *Pegase et le dragon* c 1905–07
Oil on cardboard 47 × 63 cm
(Rijksmuseum Kröller-Müller, Otterlo)

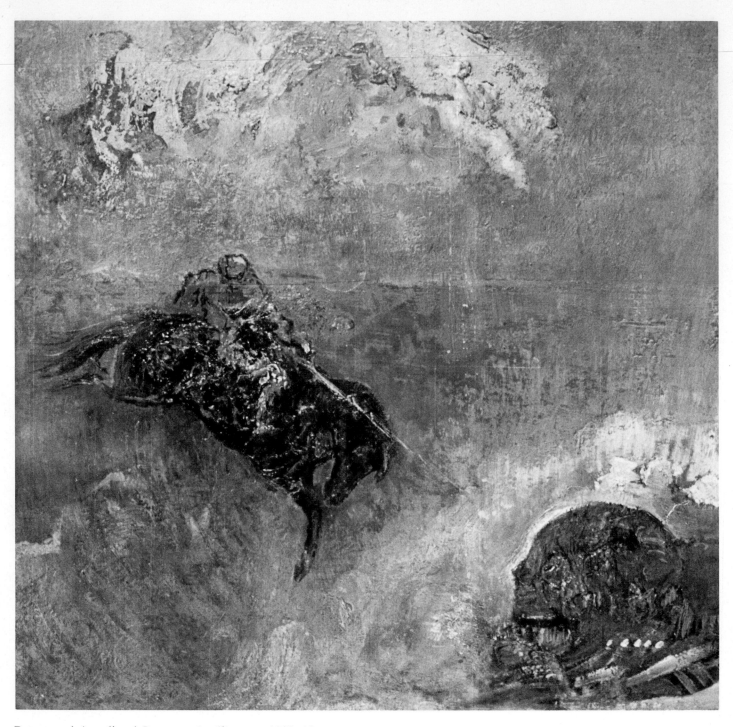

Roger and Angelica / *Roger et Angélique* c 1908–10
Oil on cardboard 30 × 29 cm
(Rijksmuseum Kröller-Müller, Otterlo)

Oannes c 1910
Oil on canvas 64 × 49 cm
(Rijksmuseum Kröller-Müller, Otterlo)

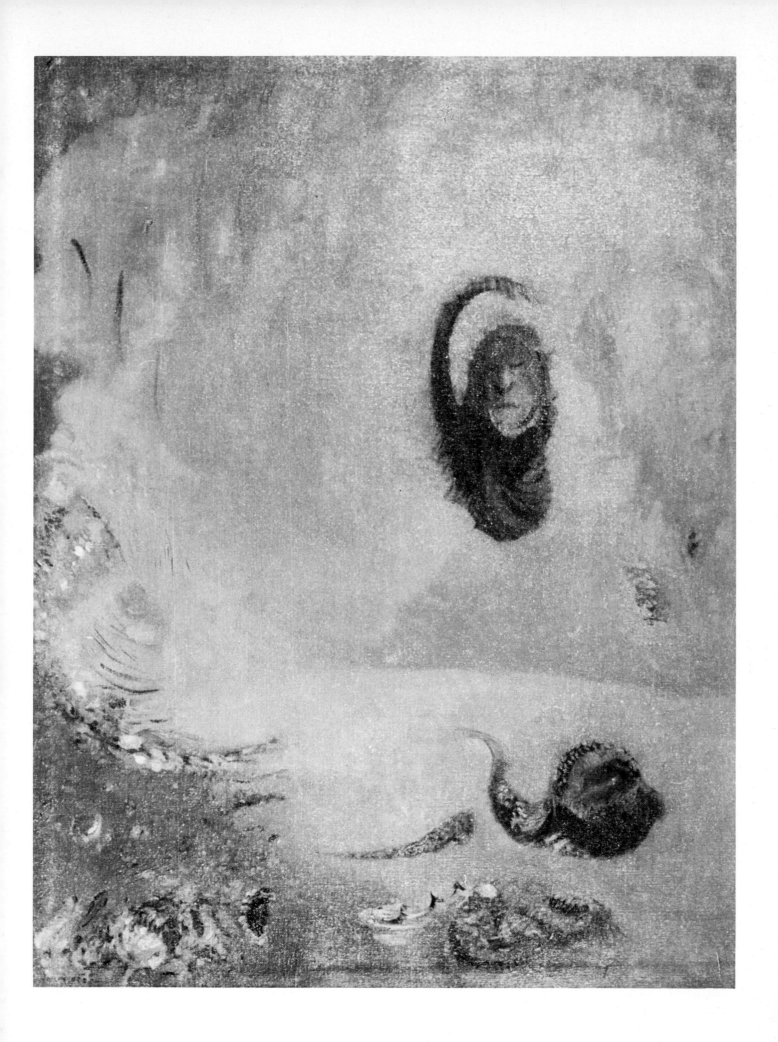

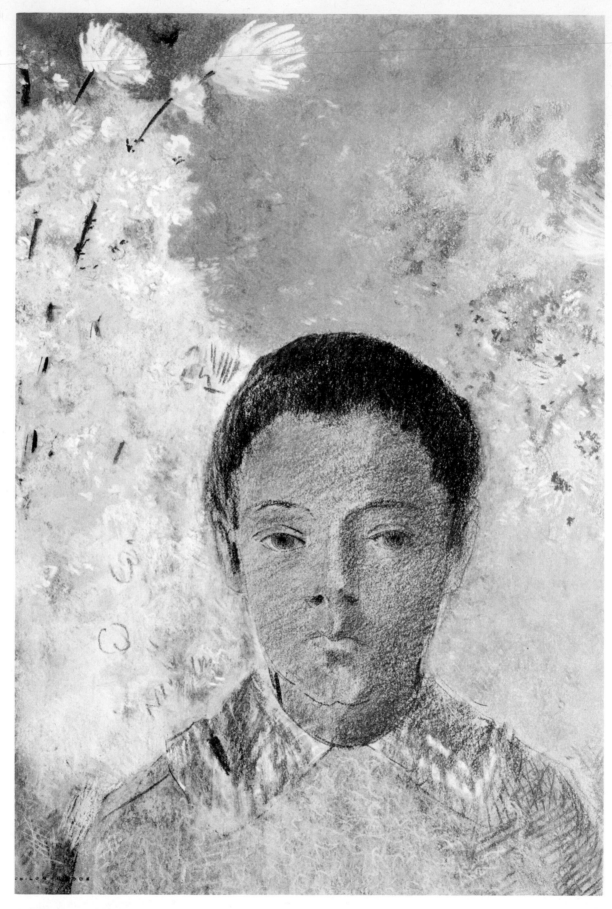

Ari Redon 1897
Pastel 44×32 cm
(Art Institute of Chicago; bequest of Kate L. Brewster)

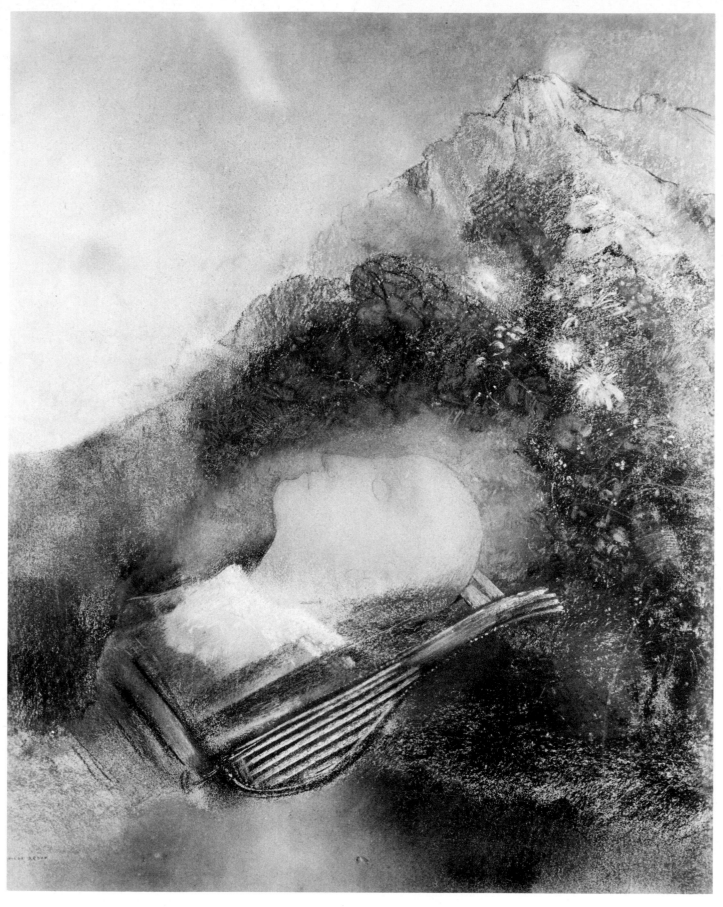

Orpheus / *Orphée* after 1903
Pastel 70 × 57 cm
(Cleveland Museum of Art, gift of J. H. Wade)

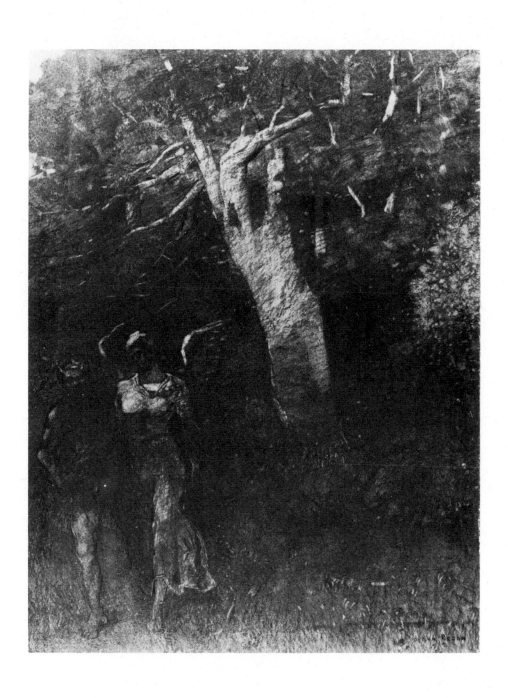

Angel and demon / *Ange et démon* *c* 1883
Charcoal 45 × 36 cm
(Musée des Beaux-Arts, Bordeaux; photo A. Danvers)

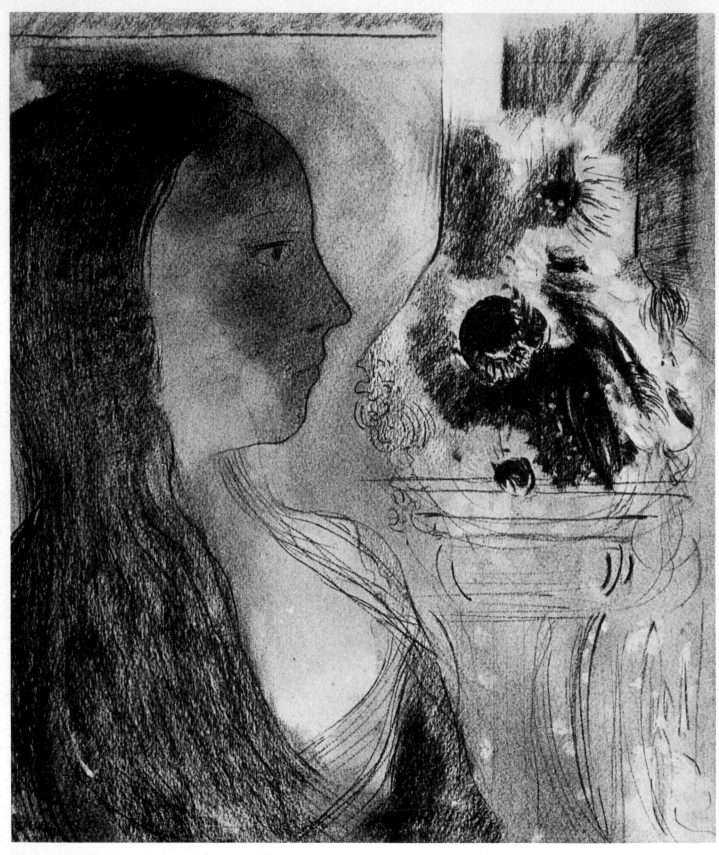

Woman with flowers / *Femme et fleurs* *c* 1890–95
Charcoal 44 × 37 cm
(Rijksmuseum Kröller-Müller, Otterlo)

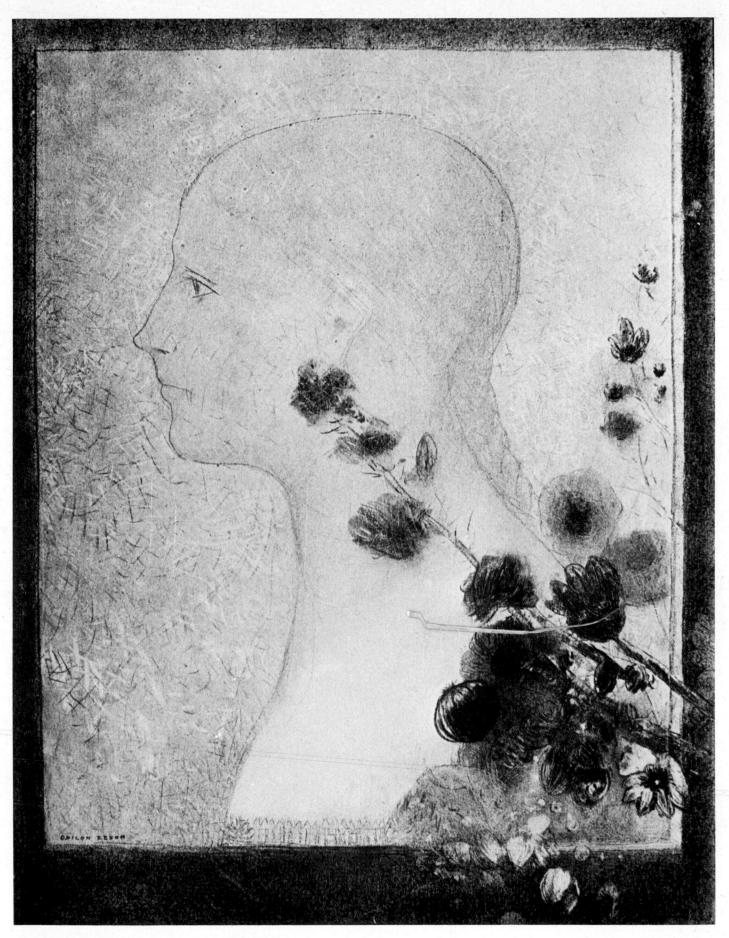

Woman in profile with flowers / *Profil de femme avec*
fleurs c 1890–95
Charcoal 50×37 cm
(Rijksmuseum Kröller-Müller, Otterlo)

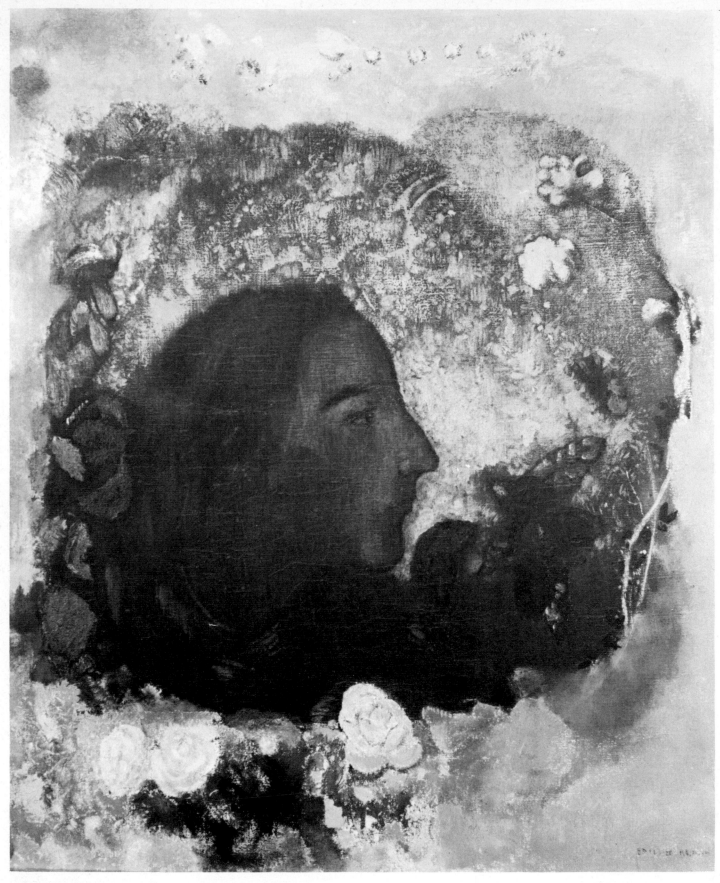

Portrait of Gauguin / *Portrait de Gauguin* 1904
Oil on canvas 66 × 55 cm
(Musées Nationaux, Paris)

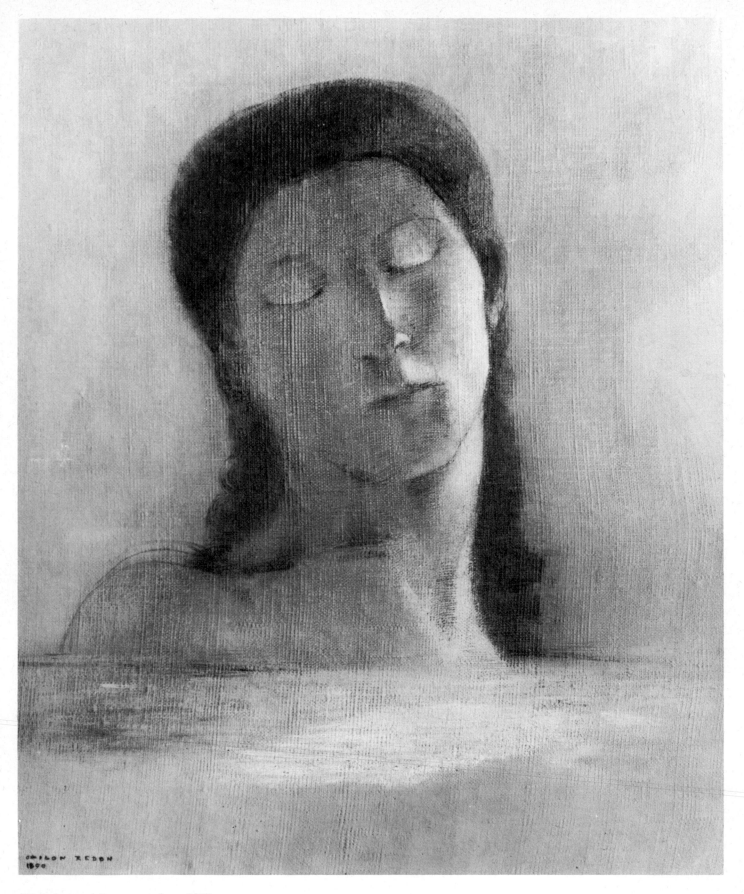

Closed eyes / *Les yeux clos* 1890
Oil on canvas mounted on board 44 × 36 cm
(Musées Nationaux, Paris)

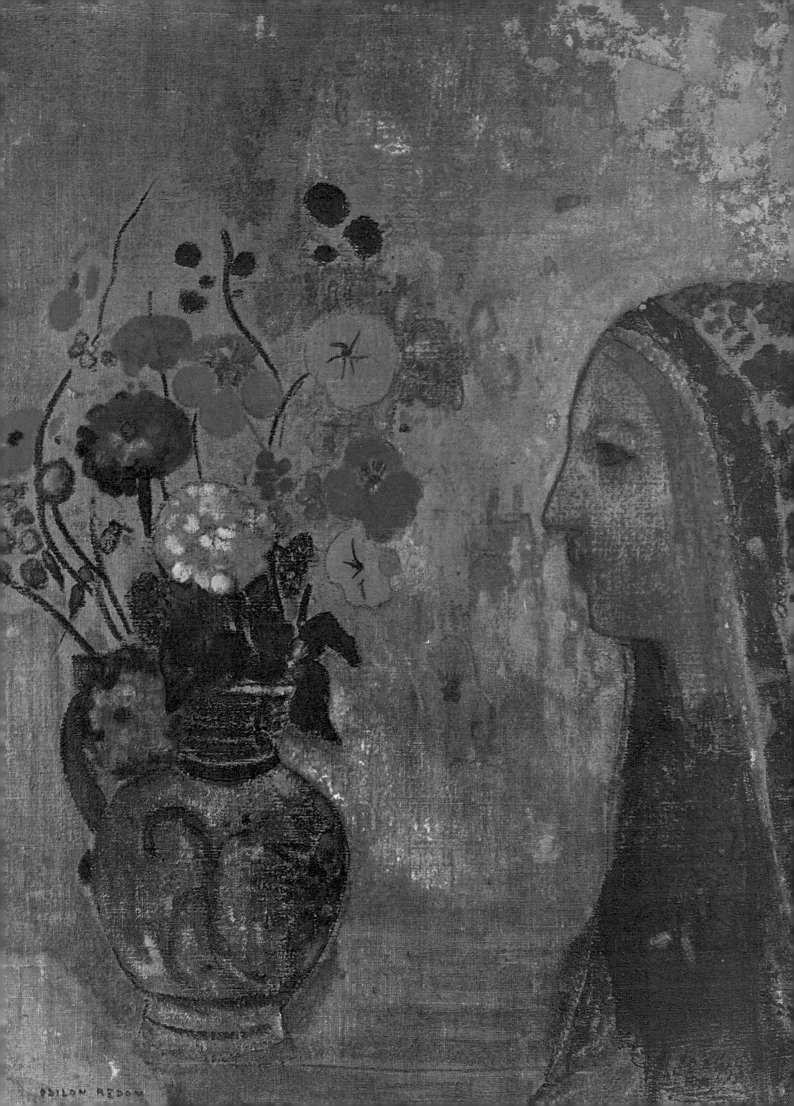

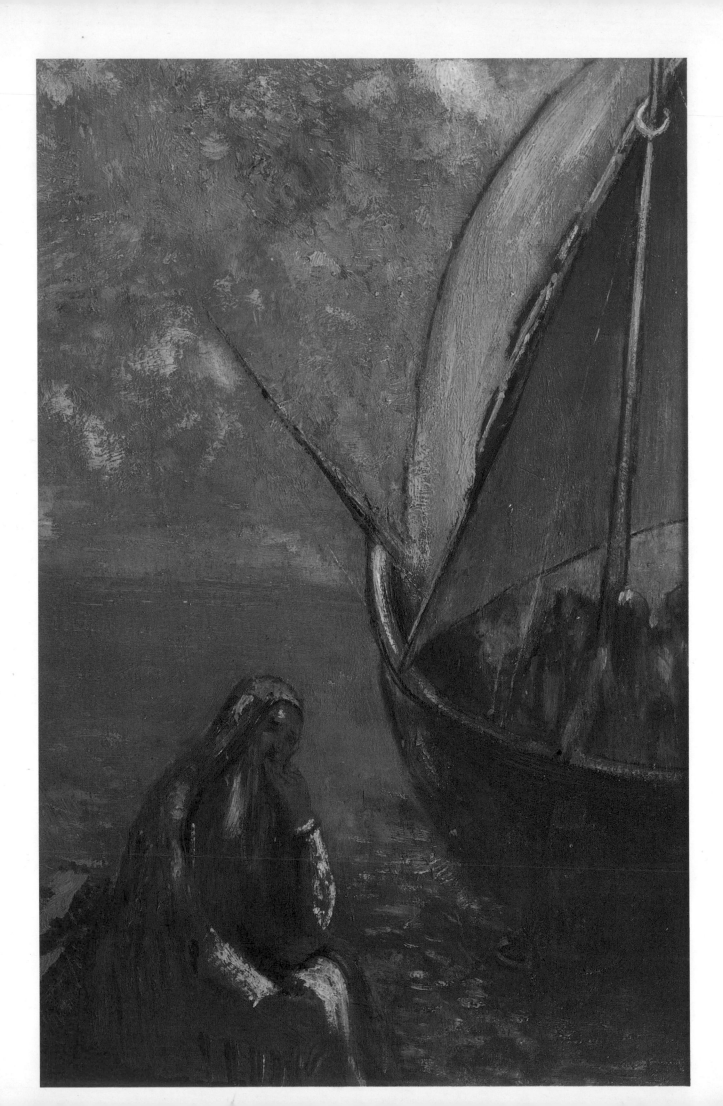

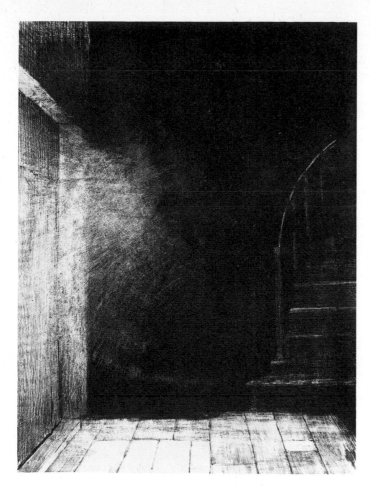

I saw a large pale light / *Je vis une lueur large et pâle*, No. 2 of *La Maison hantée* (translation of *The Haunted and the Haunters* by Edward Bulwer-Lytton) 1896
Lithograph 23 × 17 cm

It was a hand which seemed as much of flesh and blood as my own / *Selon toute apparence, c'était une main de chair et de sang comme la mienne*, No. 4 of *La Maison hantée* (translation of *The Haunted and the Haunters* by Edward Bulwer-Lytton) 1896
Lithograph 24.5 × 17.8 cm

Opposite

The departure / *Le départ*
Oil on board 41 × 27 cm
(Courtesy of Arthur Tooth & Sons Ltd)

47

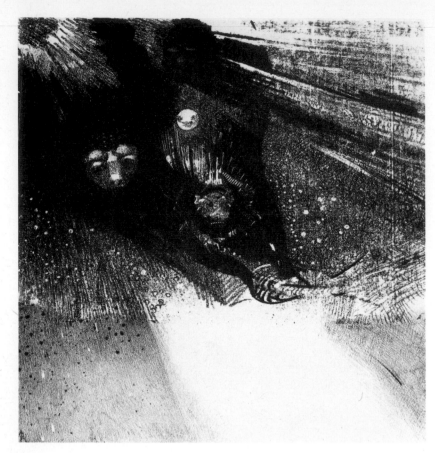

Larvae so bloodless and hideous / *Des larves si hideuses*,
No. 5 of *La Maison hantée* (translation of *The Haunted
and the Haunters* by Edward Bulwer-Lytton) 1896
Lithograph 17.9 × 17 cm

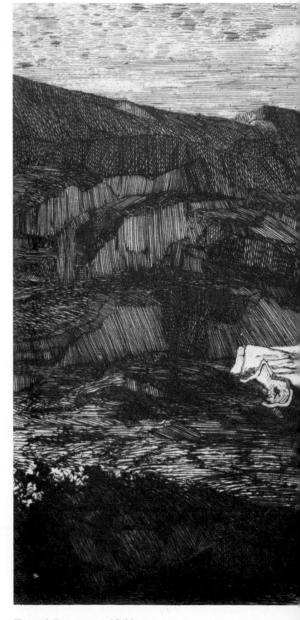

Fear / *La peur* 1865
Etching 11.2 × 20 cm

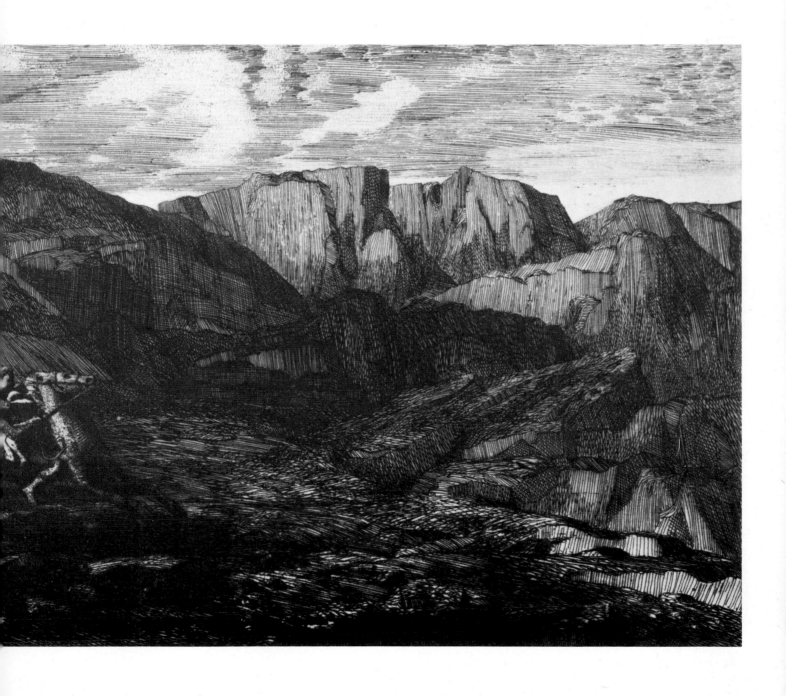

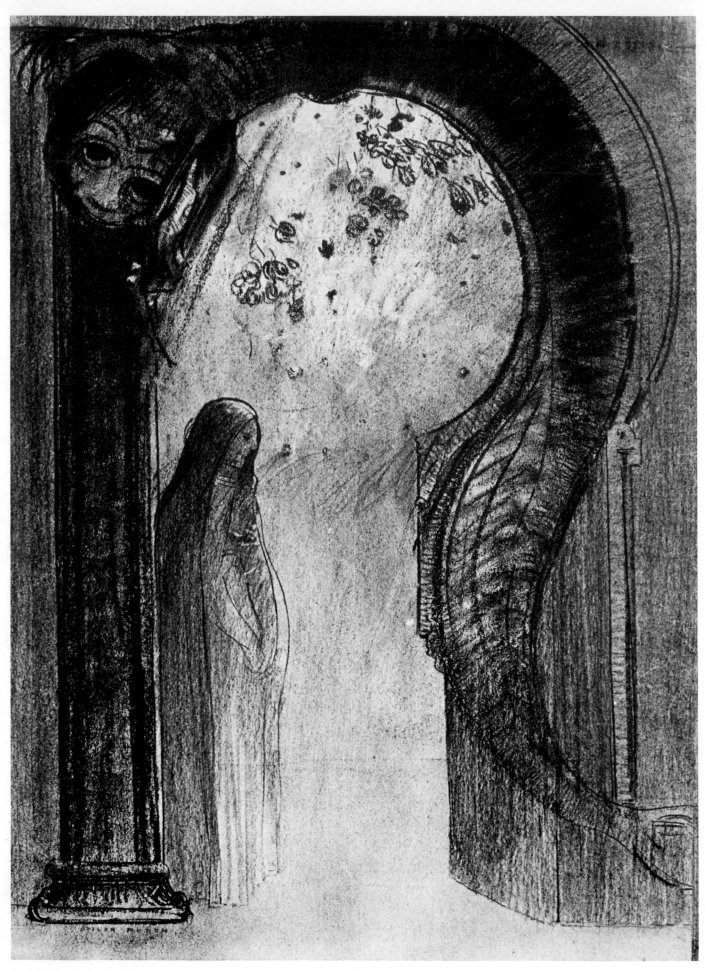

Woman and snake / *Femme et serpent* c 1885–90
Charcoal 51 × 36 cm
(Rijksmuseum Kröller-Müller, Otterlo)

50

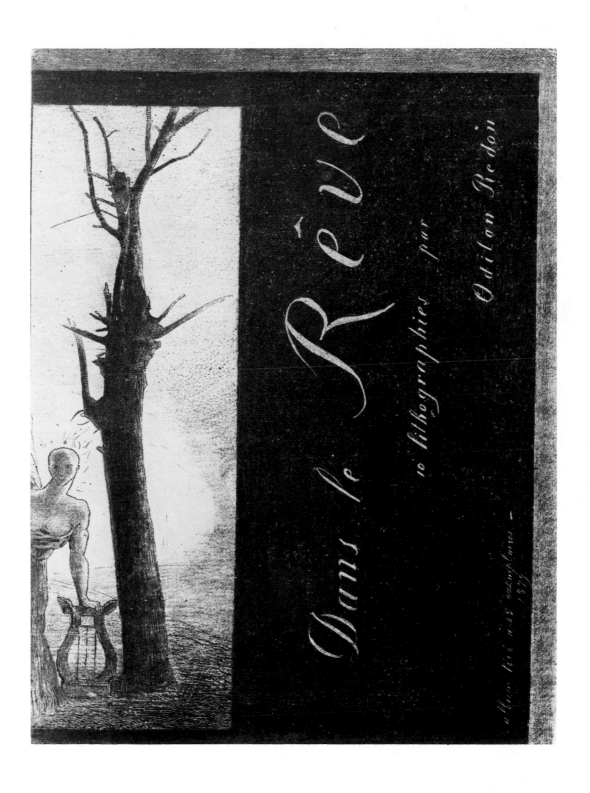

Cover of *Dans le Rêve* 1879
Lithograph 30.2 × 22.3 cm

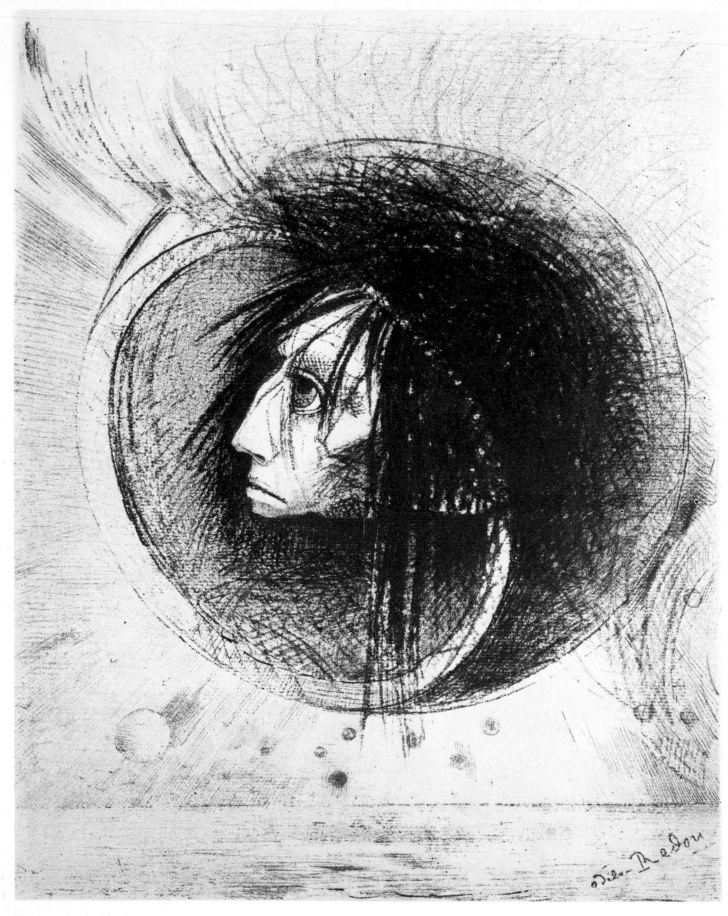

Blossoming / *Eclosion*, No. 1 of *Dans le Rêve* 1879
Lithograph 32.8 × 25.7 cm

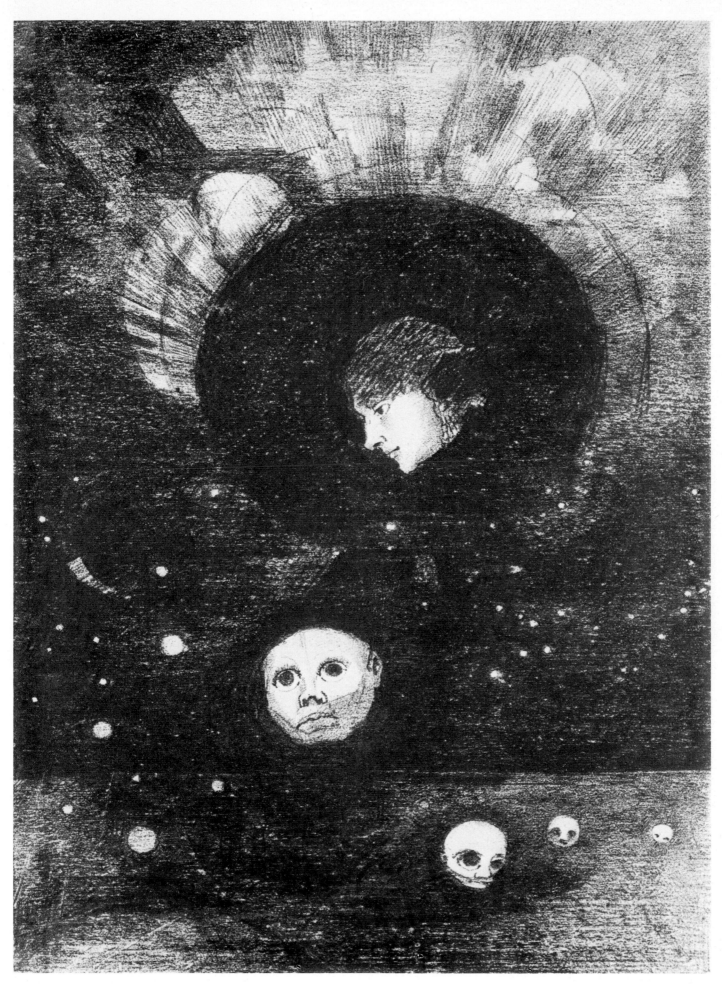

Germination, No. 2 of *Dans le Rêve* 1879
Lithograph 27.3 × 19.4 cm

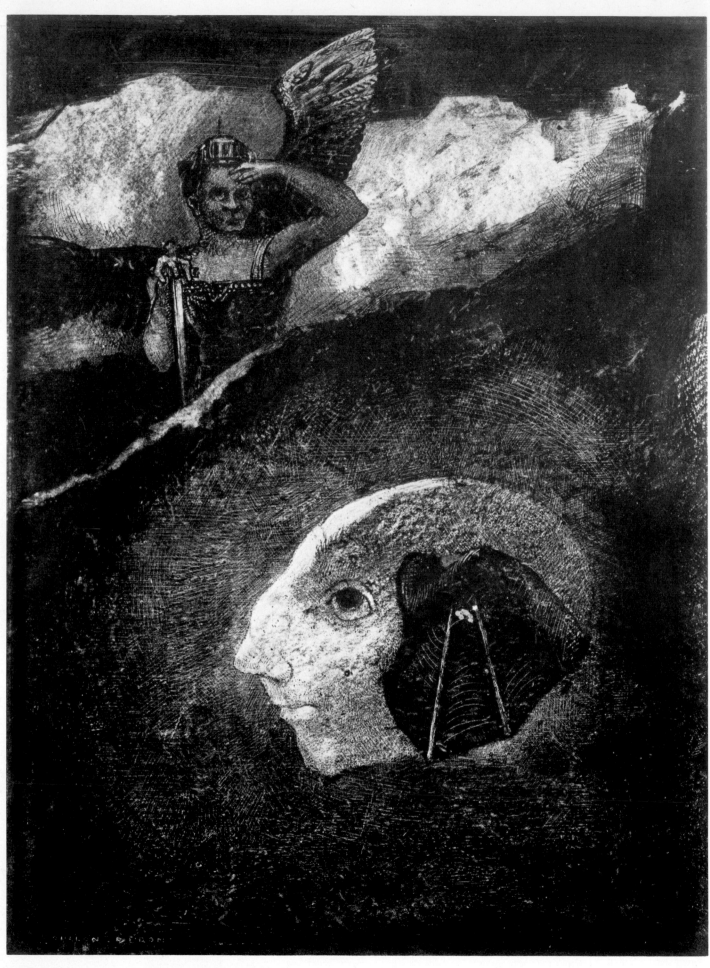

Limbo / *Limbes*, No. 4 of *Dans le Rêve* 1879
Lithograph 30.7 × 22.3 cm

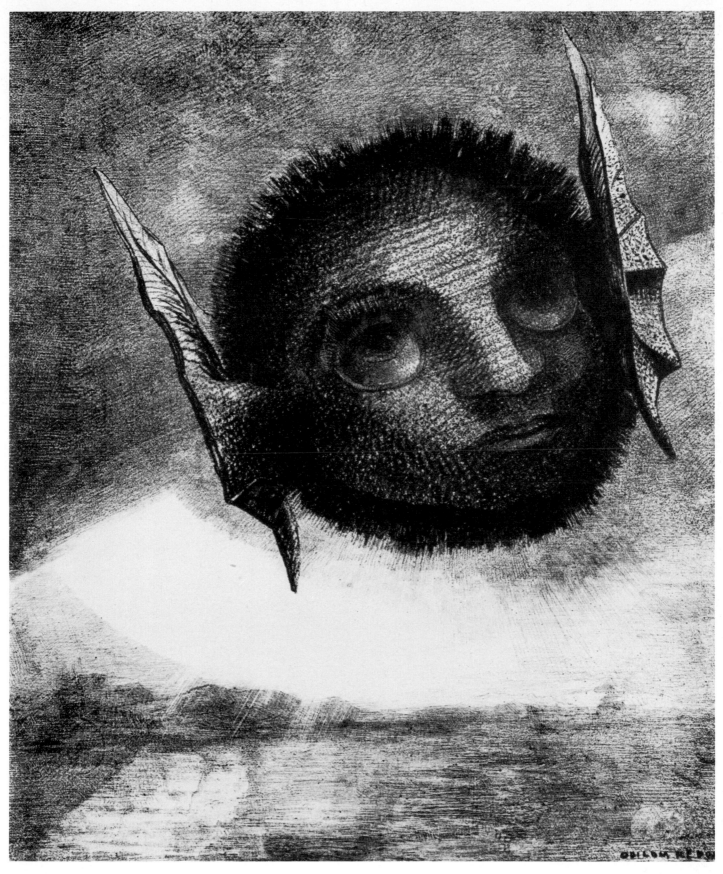

Gnome, No. 6 of *Dans le Rêve* 1879
Lithograph 27.2 × 22 cm

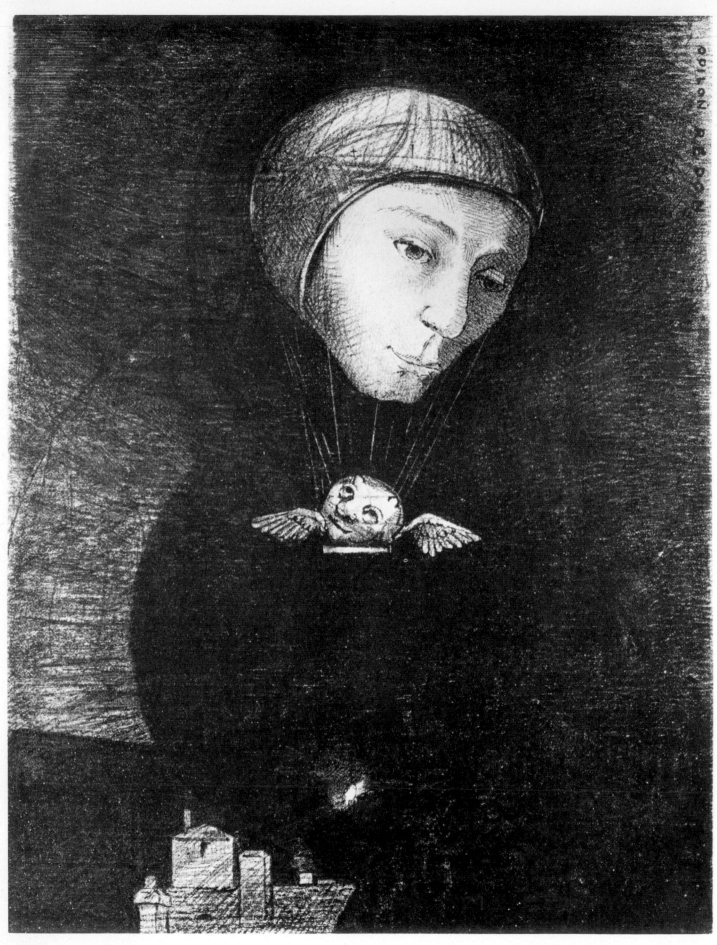

Sad ascent / *Triste montée*, No. 9 of *Dans le Rêve* 1879
Lithograph 26.7 × 20 cm

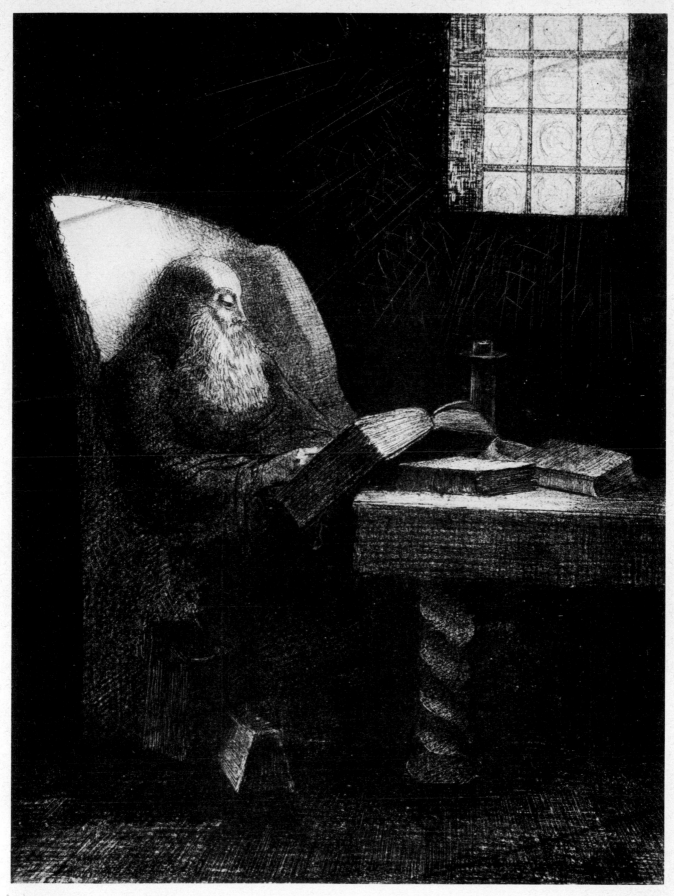

The reader / *Le liseur* 1892
Lithograph 31 × 23.6 cm

Opposite
Blue profile / *Profil bleu*
Pastel 30.2 × 24.7 cm
(British Museum)

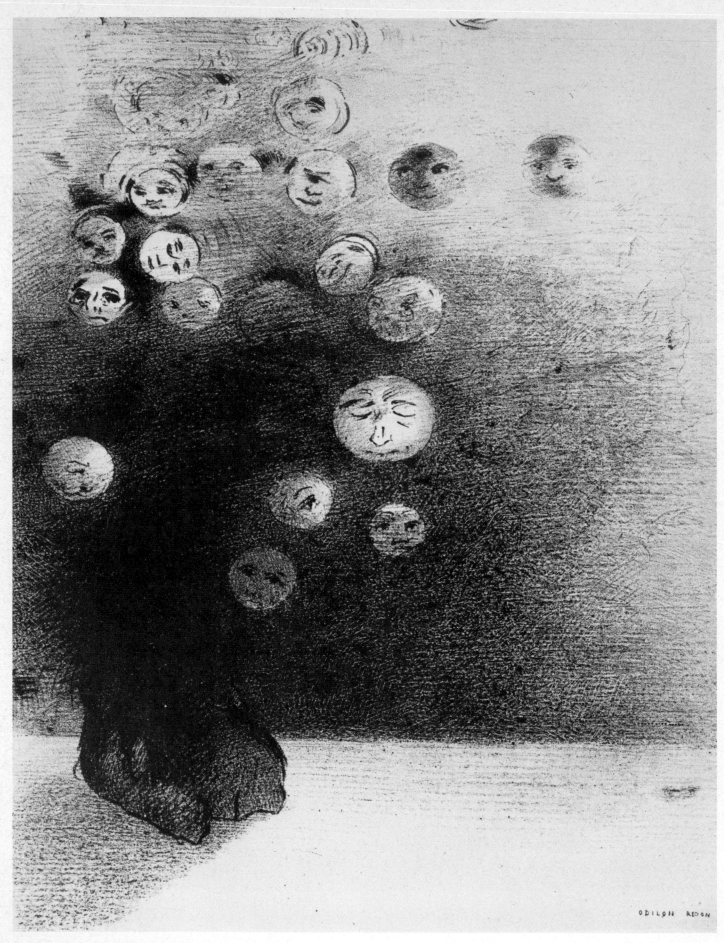

Is there not an invisible world / *N'y a-t-il pas un monde invisible*, from *Le Juré* 1887
Lithograph 21.8 × 16.9 cm

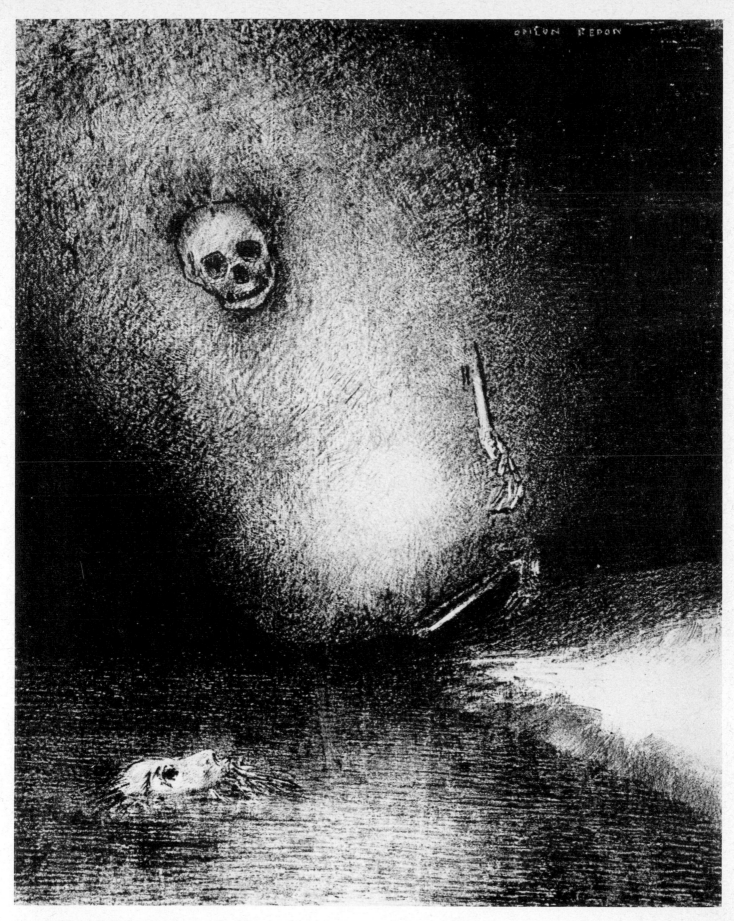

The dream ends in death / *Le rêve s'achève par la mort*,
from *Le Juré* 1887
Lithograph 23.8 × 18.7 cm

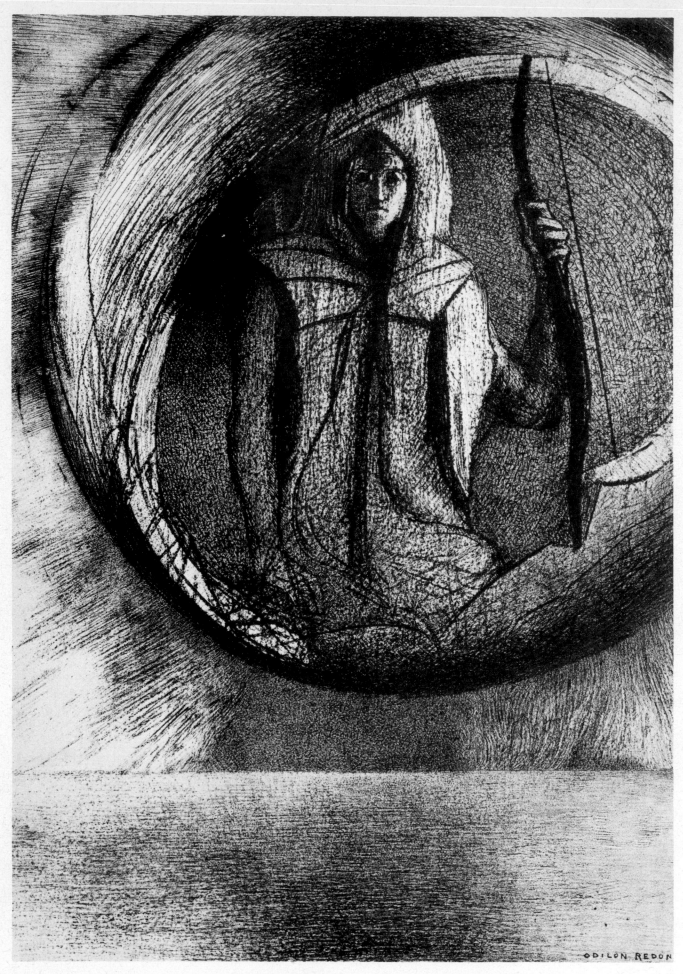

And beyond, the astral idol, the apotheosis / *Et là-bas,
l'idole astrale, l'apothéose*, No. 2 of *Songes* 1891
Lithograph 27.7 × 19.2 cm

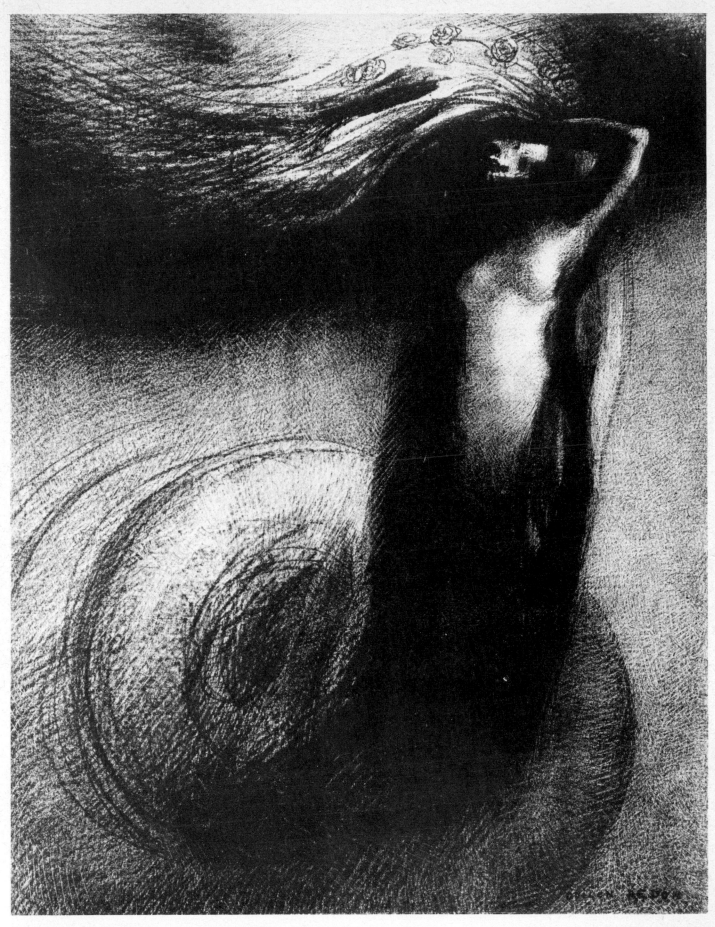

Death: My irony surpasses all others / *La Mort: Mon
ironie dépasse toutes les autres*, No. 3 of *A Gustave
Flaubert* 1889
Lithograph 26.2 × 19.7 cm

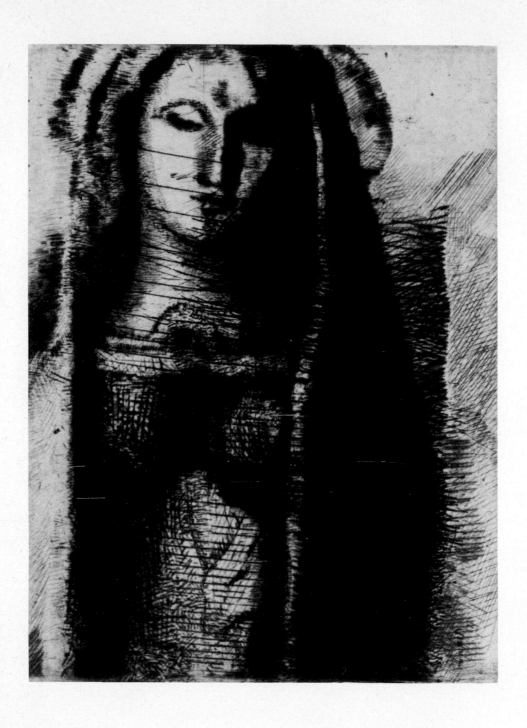

Princess Maleine or The Small Madonna / *La petite
Madone* 1892
Etching 11.9 × 6.4 cm

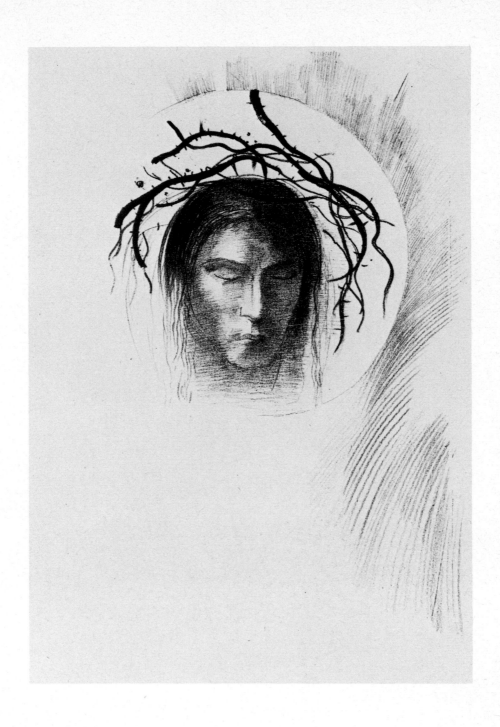

Day appears at last, . . . and in the very disc of the sun
shines the face of Jesus Christ / *Le jour enfin paraît, . . . et*
dans le disque même du soleil, rayonne la face de
Jésus-Christ, No. 24 of *La Tentation de Saint-Antoine* 1896
Lithograph 27 × 26.3 cm

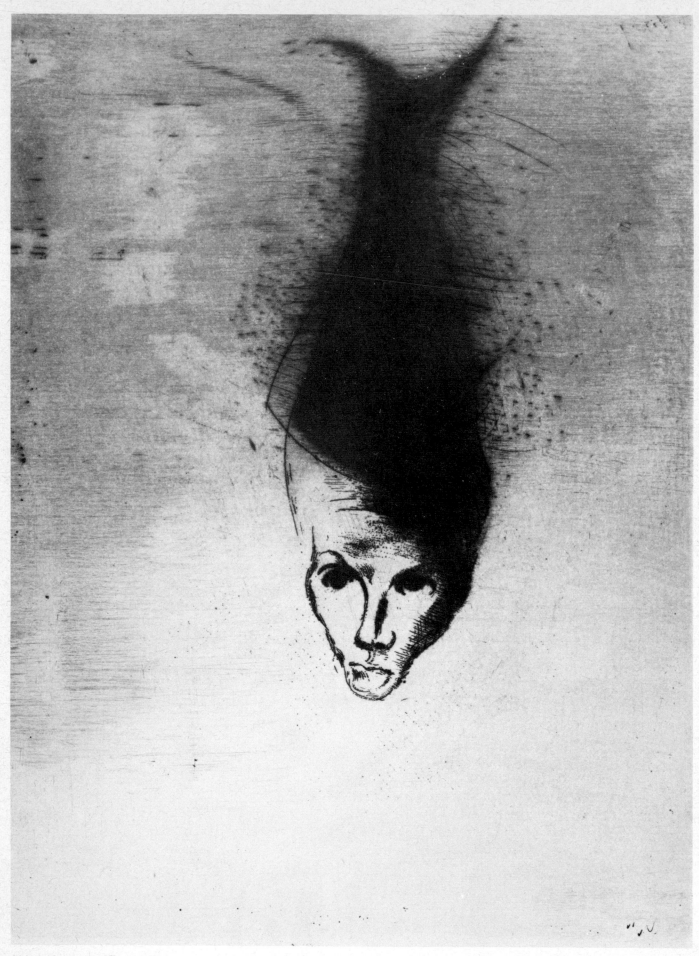

Skiapod / *Sciapode* 1892
Etching 19 × 14 cm

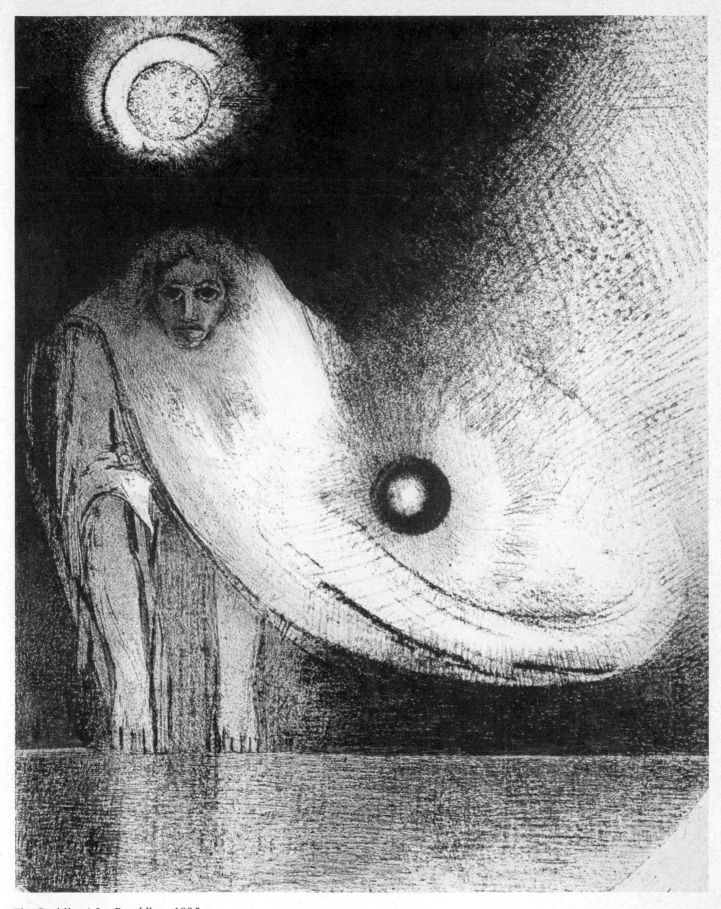

The Buddha / *Le Bouddha* 1895
Lithograph 32.4 × 24.9 cm

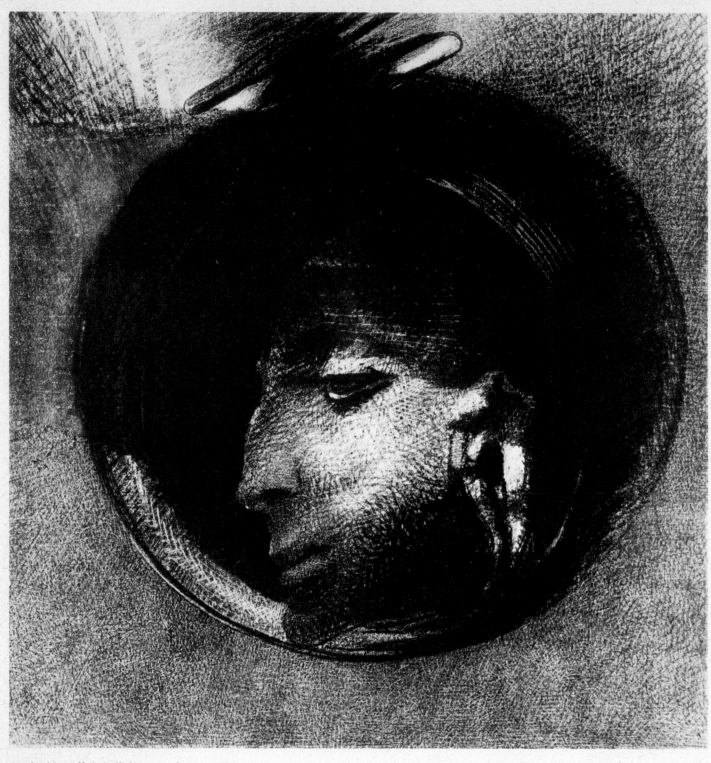

Auricular cell / *Cellule auriculaire* 1894
Lithograph 26.8 × 25 cm